A Keepsake

MARTHA'S VINEYARD

Arthur P. Richmond

4880 Lower Valley Road • Atglen, PA 19310

To Charles Douglas

INTRODUCTION

South of Cape Cod and west of Nantucket, Martha's Vineyard offers year-round charm. From the town of Vineyard Haven, head "up island" to travel through West Tisbury, Chilmark, and Aquinnah with its farms and rolling hillsides. Tour Edgartown with its impressive stateliness and distinctive architecture. Then enjoy the lively town of Oak Bluffs with its carousel and Campground. Included too are the harbors with their fish docks, the beloved Black Dog Tavern, the quaint gingerbread cottages, and the red clay cliffs where Gay Head Light still signals mariners. Here is the essence of the island, in all its year-round beauty.

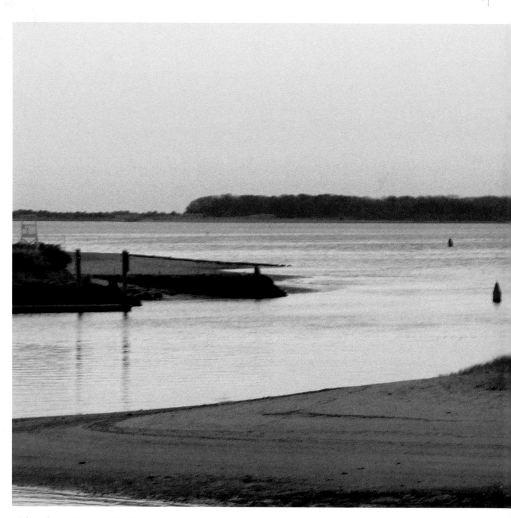

A ferry leaves Hyannis for the island.

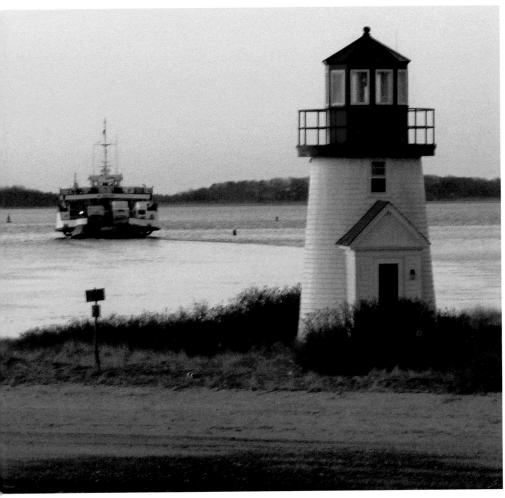

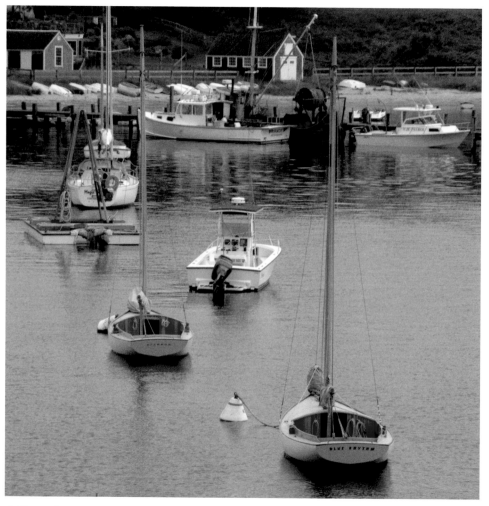

Sailboats of various sizes are found in Vineyard Haven Harbor.

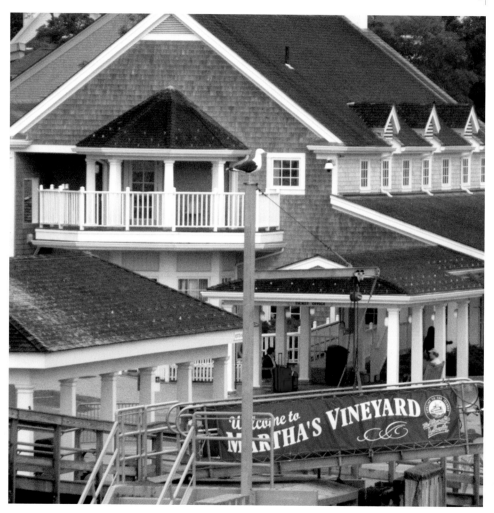

The ferry dock in Vineyard Haven.

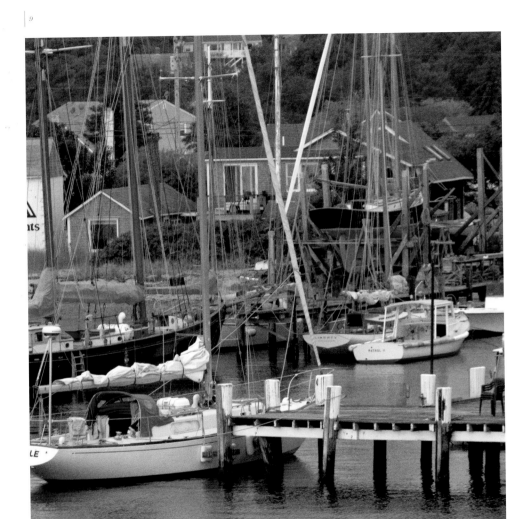

Boats tied up in Vineyard Haven.

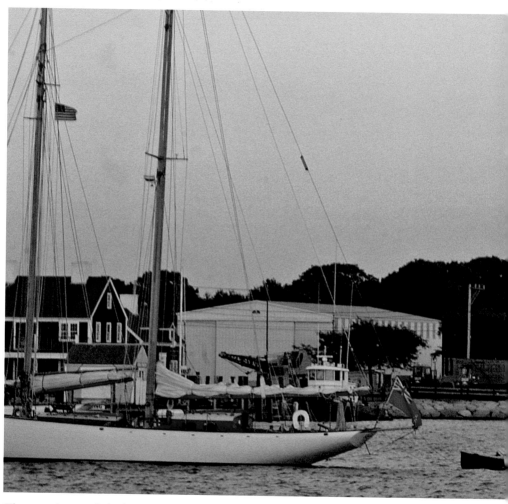

The moon rises over the harbor.

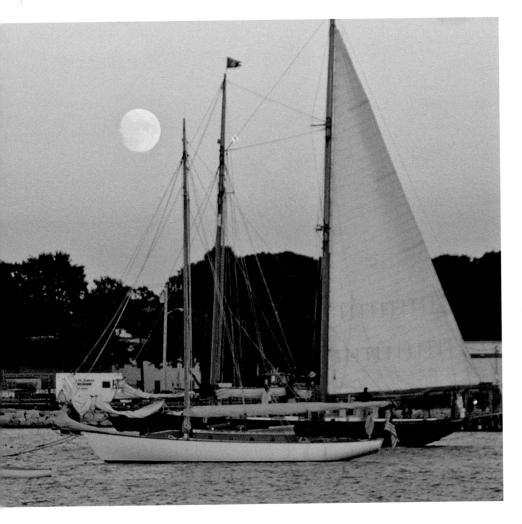

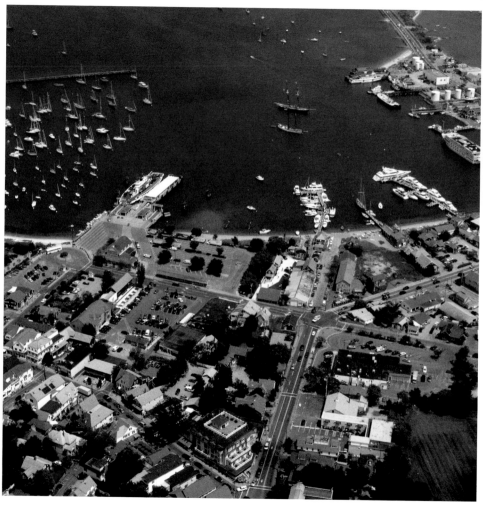

An aerial view of the harbor.

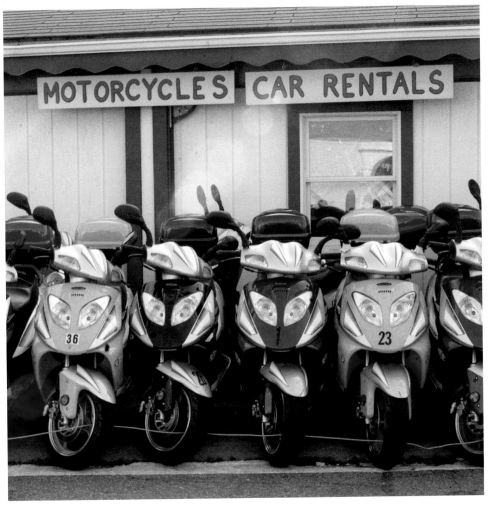

Mopeds, cars, and bikes can be rented for touring the island.

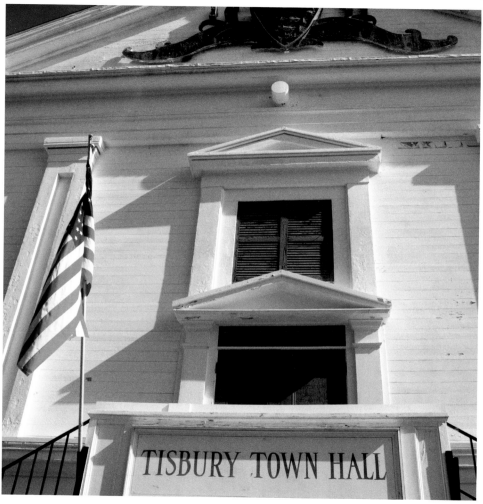

The Tisbury Town Hall.

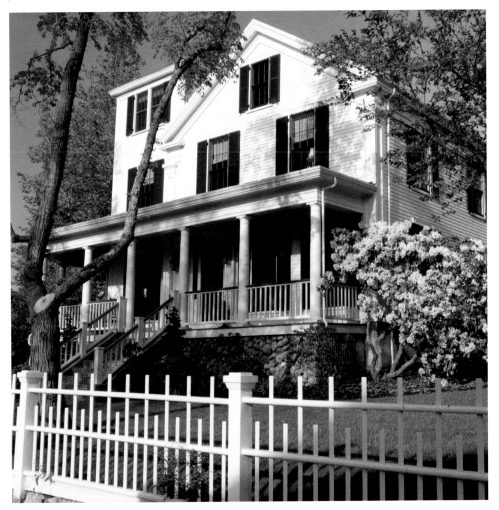

Old homes abound in Vineyard Haven.

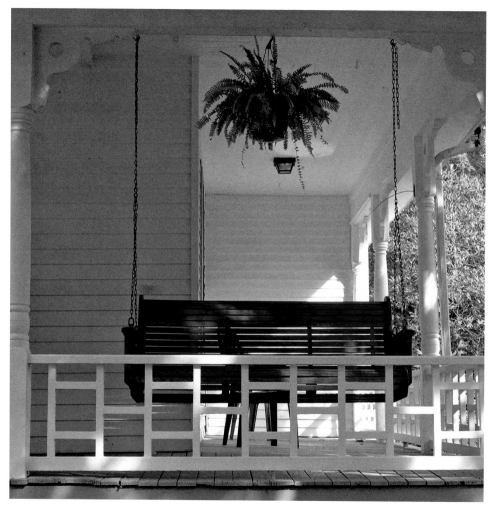

A porch swing beckons.

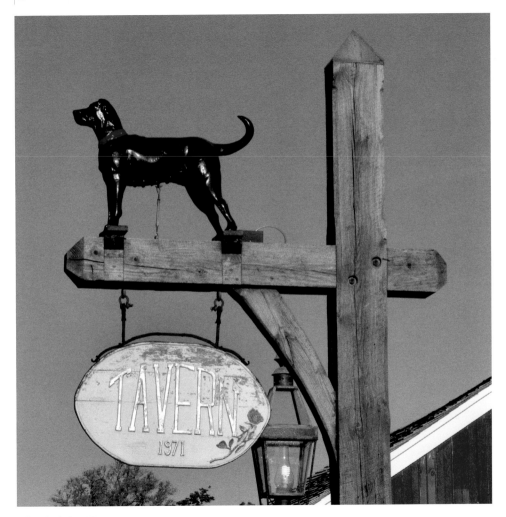

The Black Dog Tavern.

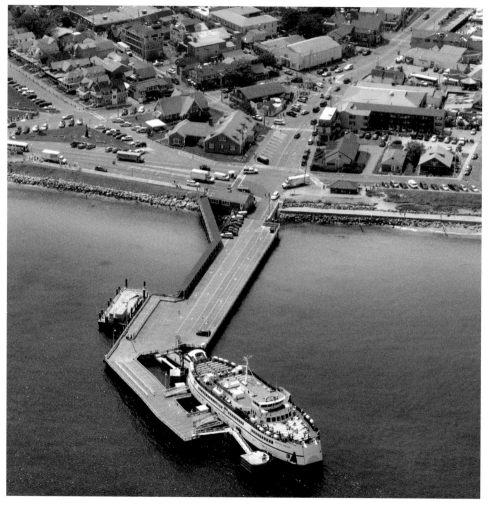

The ferry dock in Oak Bluffs.

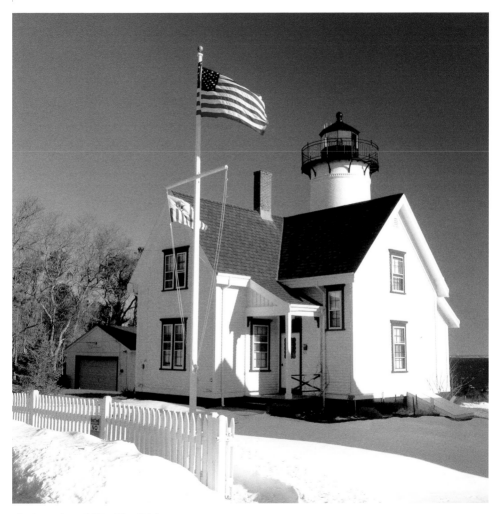

A winter view of West Chop Light.

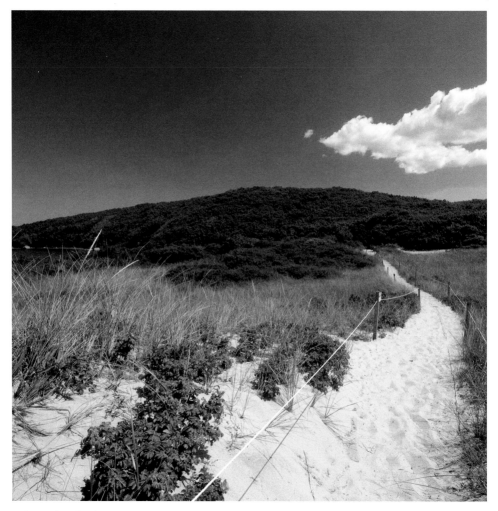

Felix Neck Wildlife Sanctuary.

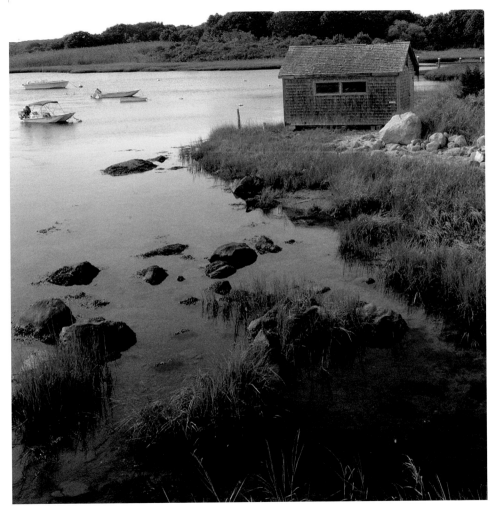

A boathouse along one of the inlets.

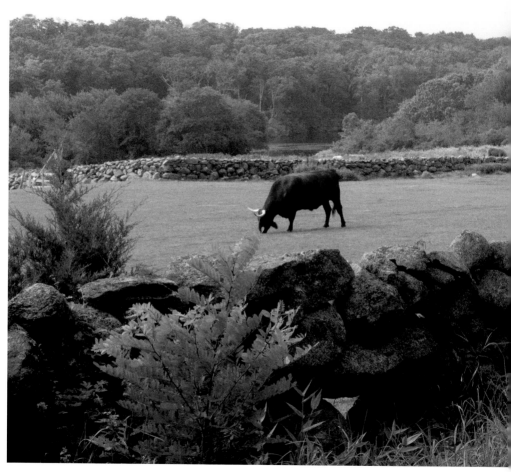

A farm in Chilmark.

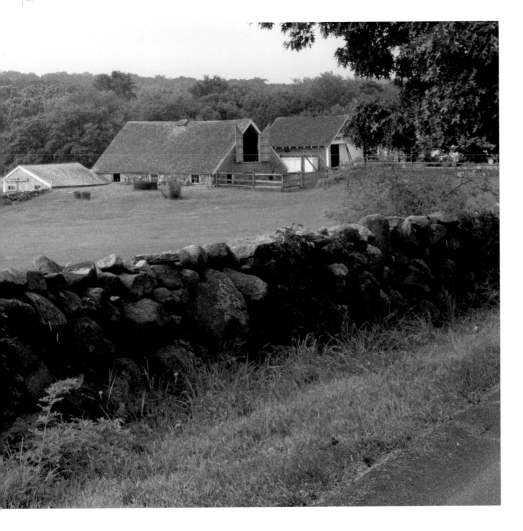

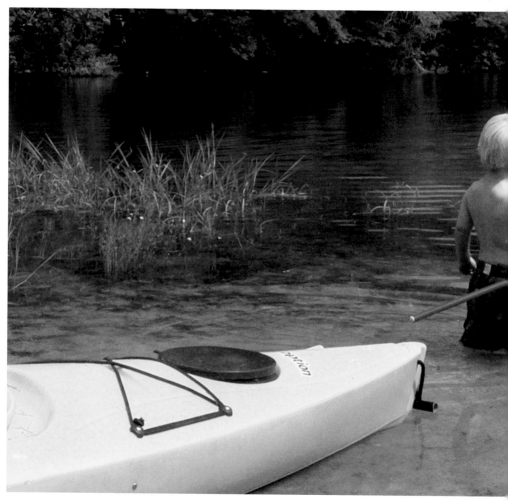

A young fisherman.

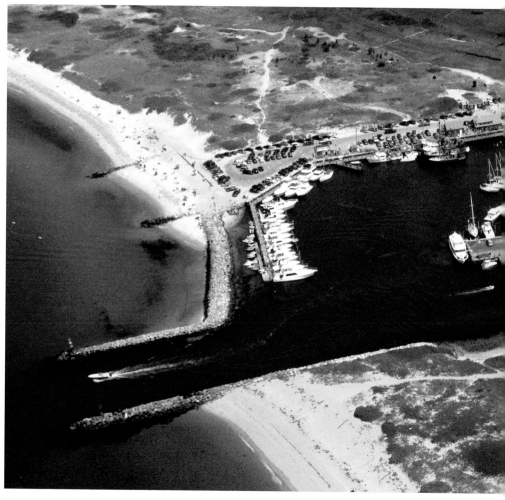

An aerial view of Menemsha Harbor.

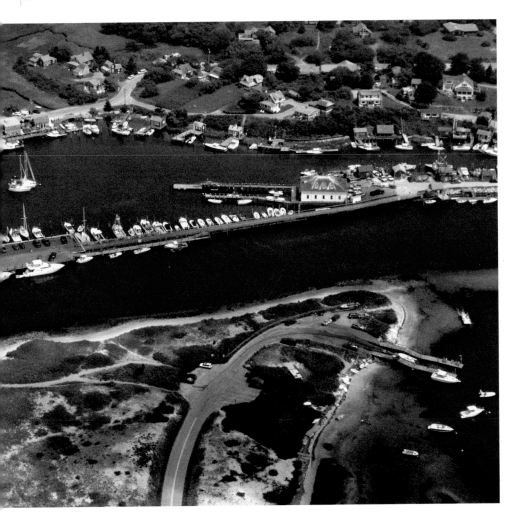

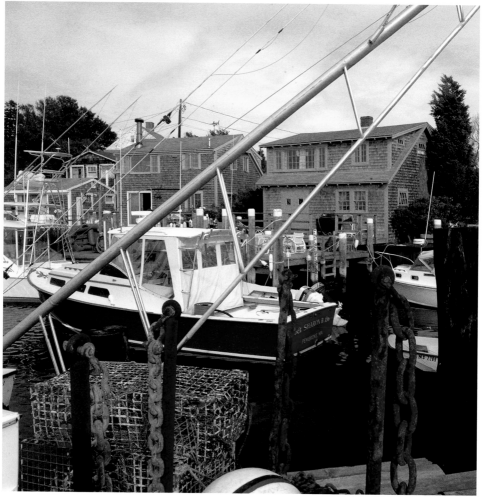

Boats in Menemsha Harbor.

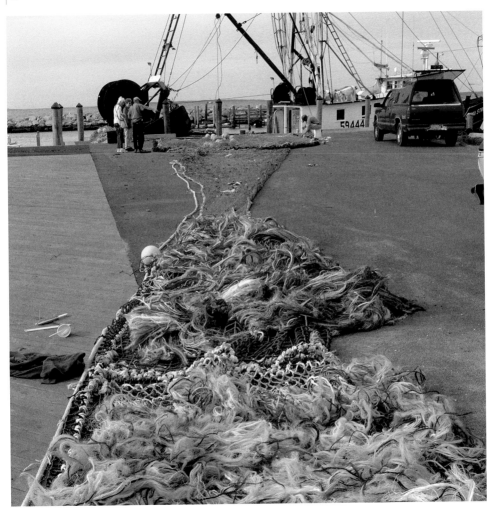

Repairing nets on the pier.

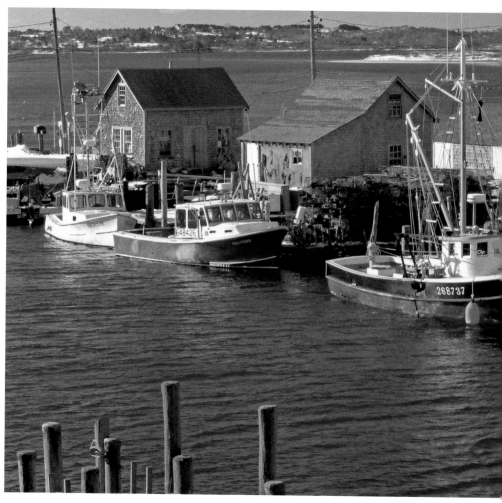

Boats and fishing shacks in Menemsha.

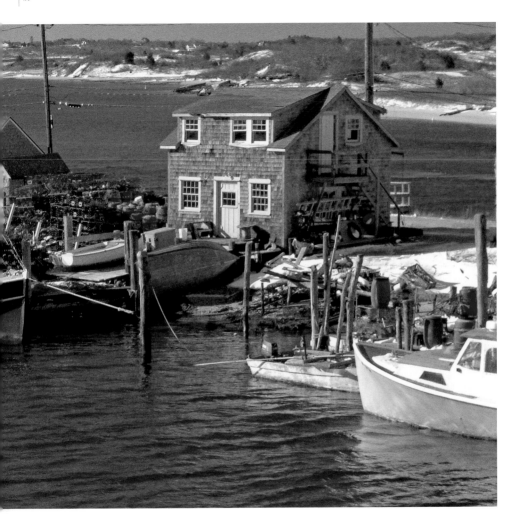

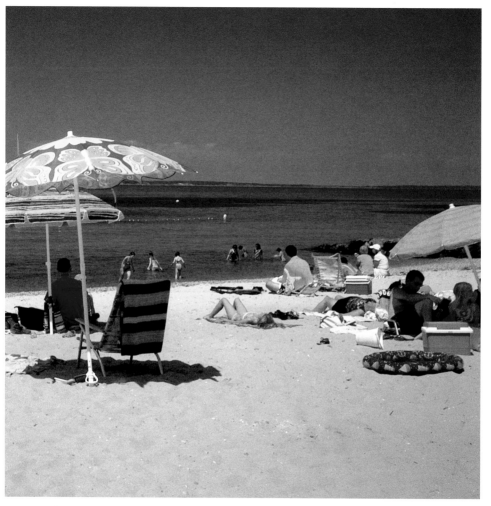

Menemsha beach.

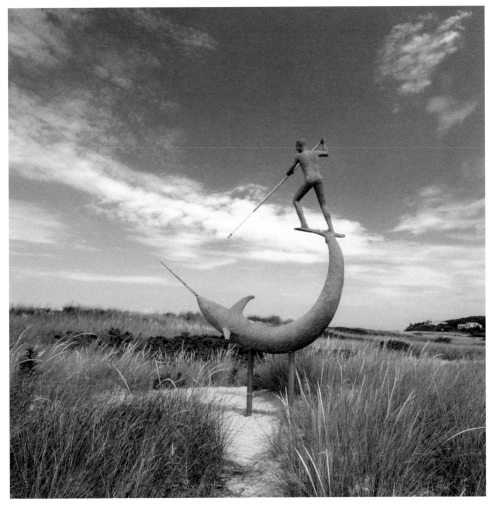

The distinctive Menamsha statue of a swordfish harpooner.

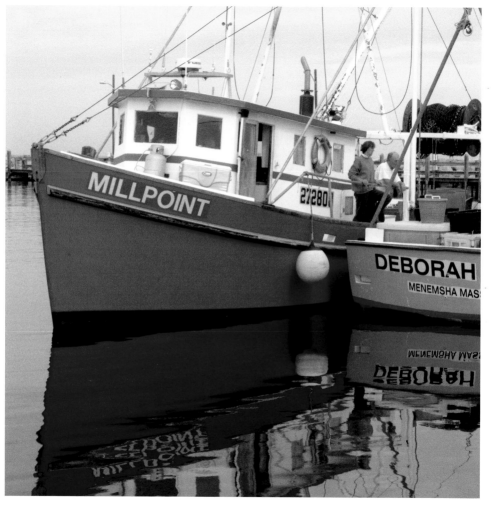

Fishing boats at the pier.

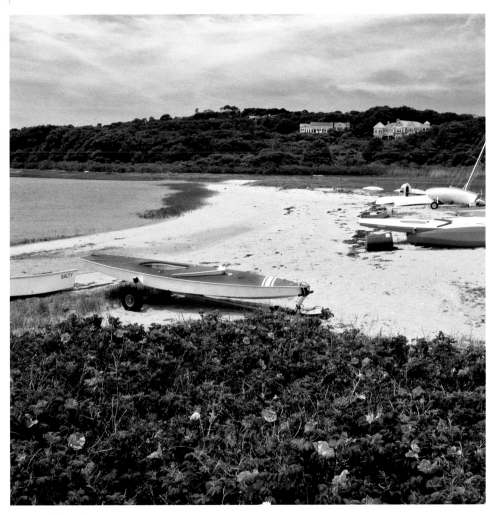

Lobsterville Beach.

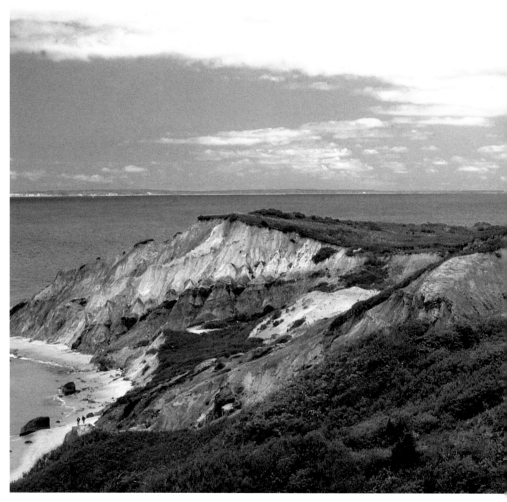

A panorama punctuated by Gay Head Lighthouse.

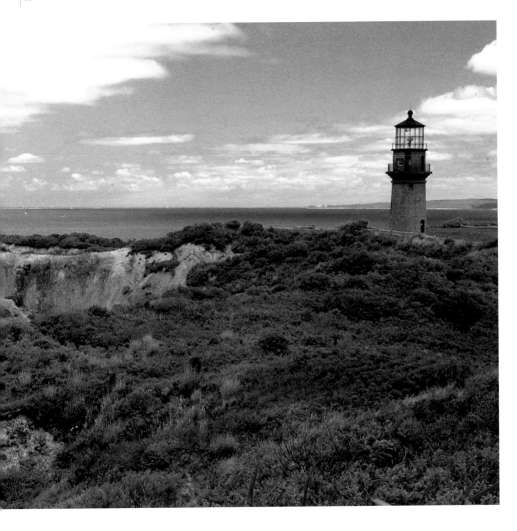

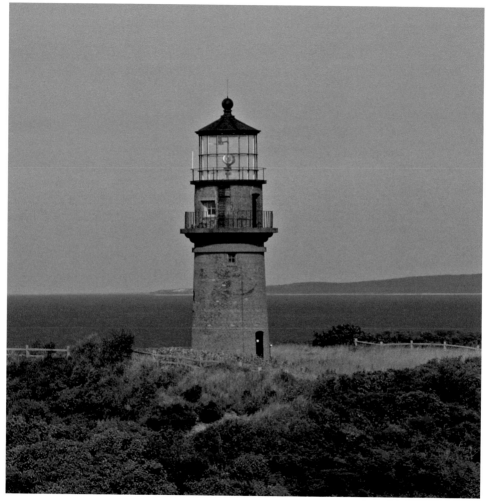

Gay Head Light before it was moved, in 2015, off the red clay cliffs.

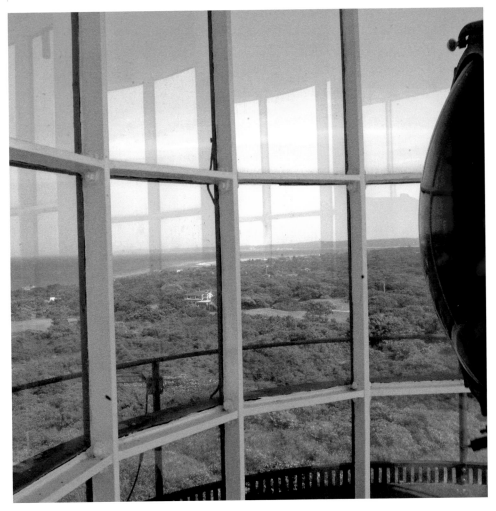

A view out the lantern room.

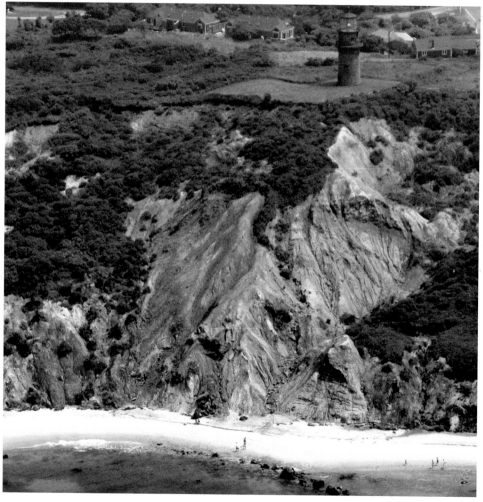

The red clay cliffs of Gay Head.

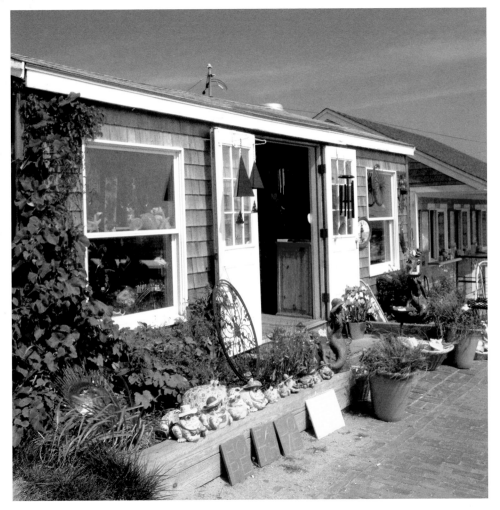

Gift shops near the lighthouse.

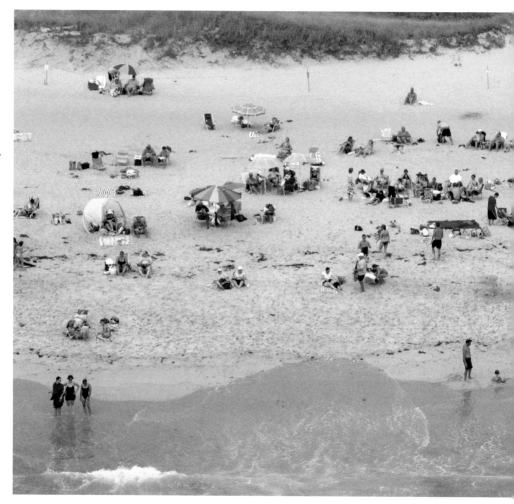

One of the beaches on the south shore.

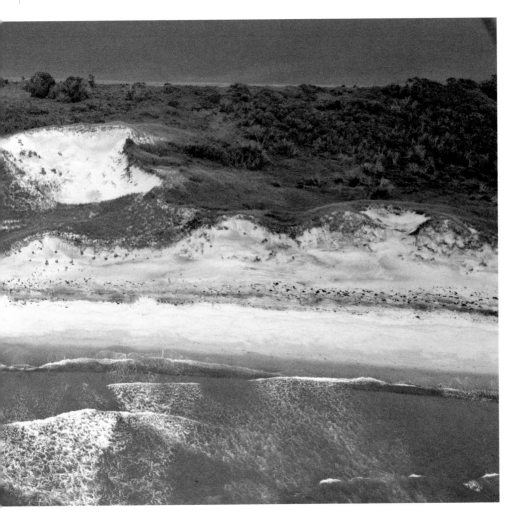

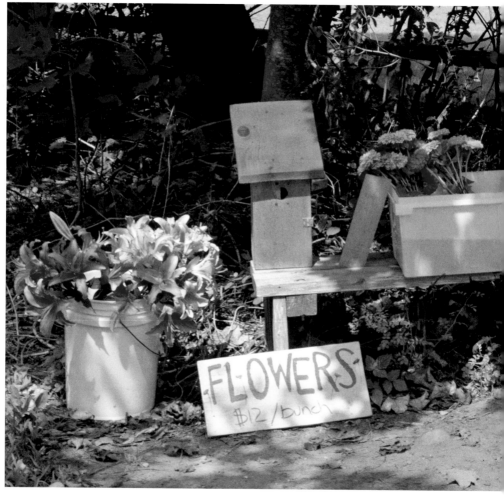

Flowers for sale along the roadside.

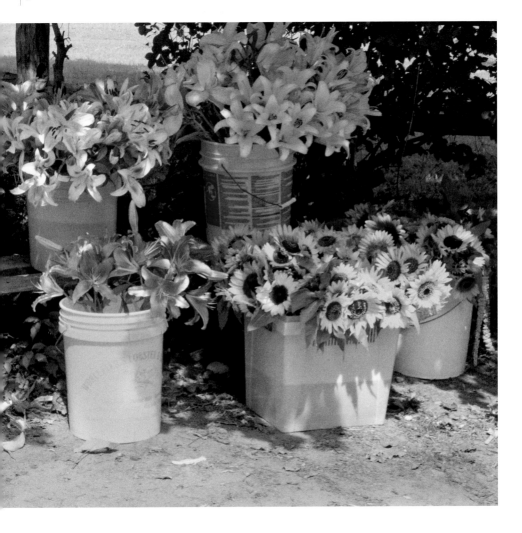

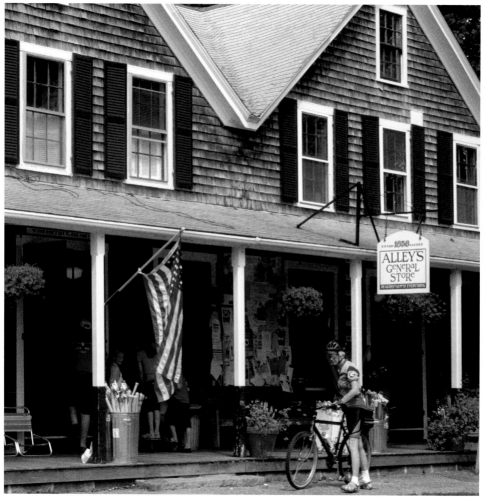

The distinctive Alley's General Store.

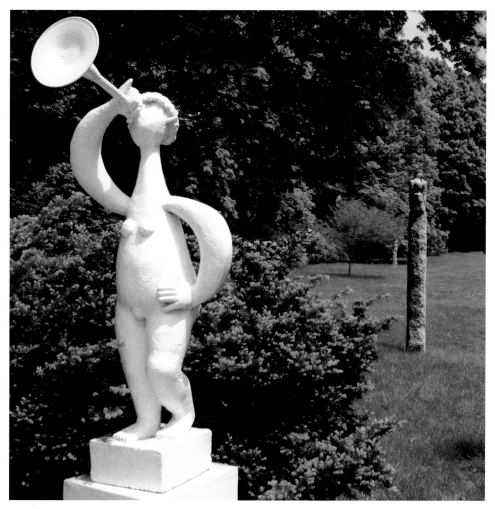

Lawn statuary.

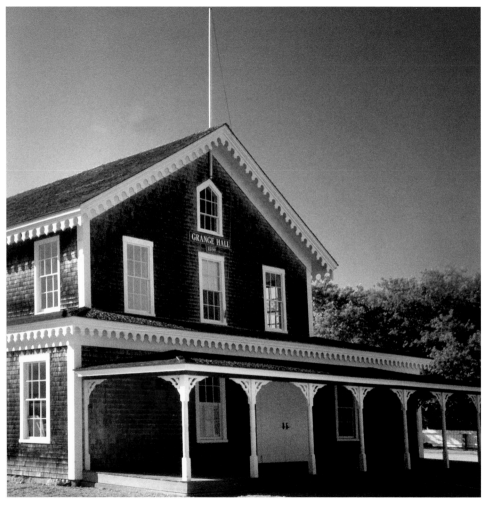

The Grange is the site of many activities.

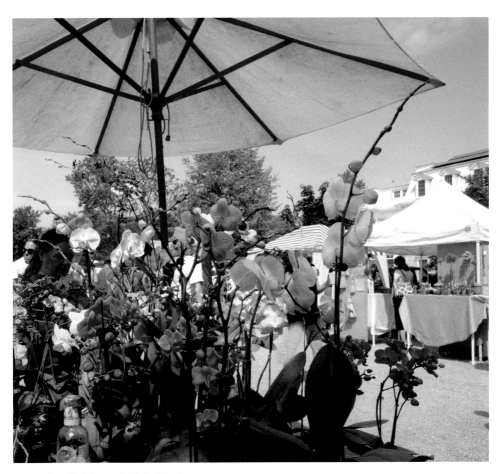

Arts and crafts fairs are held during the summer.

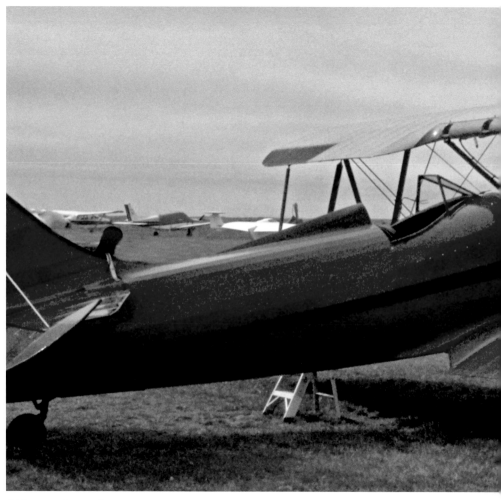

Biplanes can be rented at Katama Airport in Edgartown.

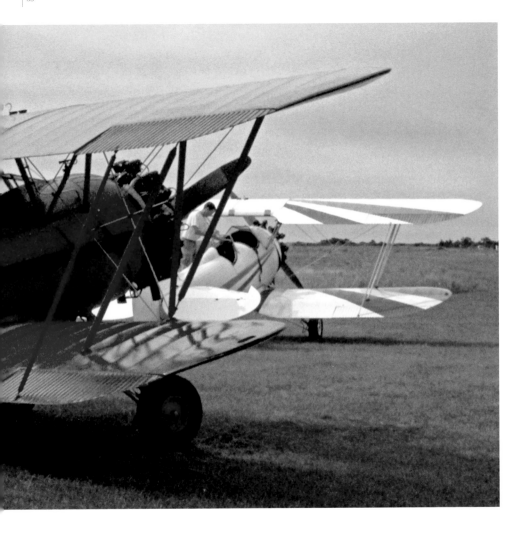

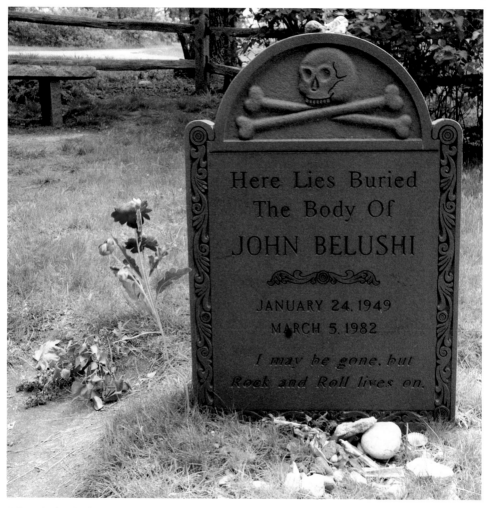

John Belushi's headstone in a Vineyard cemetery.

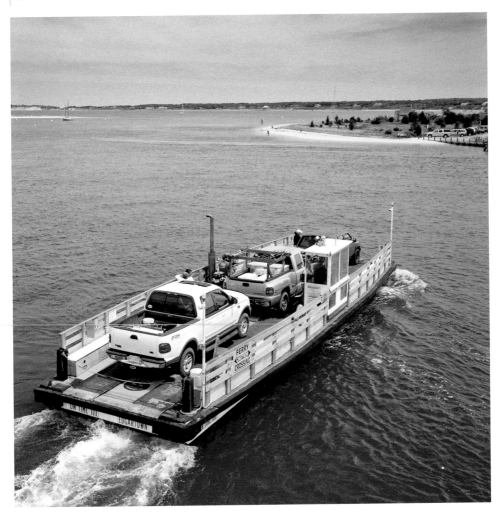

The on-time ferry to Chappaquiddick Island.

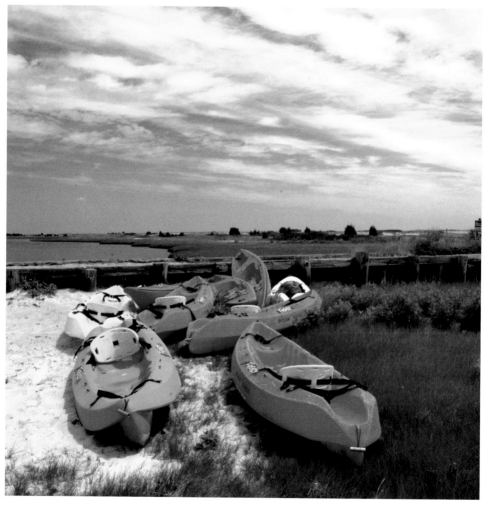

Kayaks along the shore are a common sight.

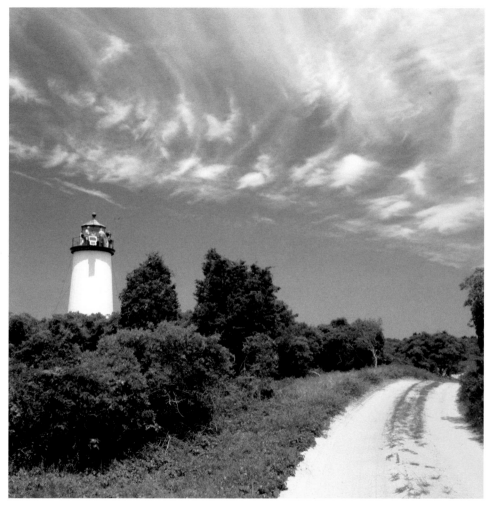

Cape Pogue Light is at the end of a long sandy road.

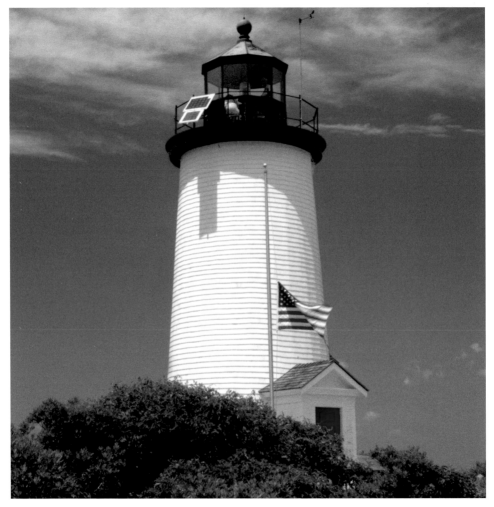

Cape Pogue Light welcomes visitors during the summer months.

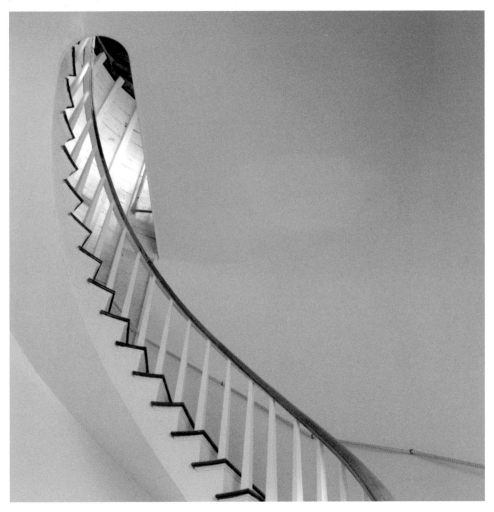

Stairs inside the lighthouse lead to the lantern room.

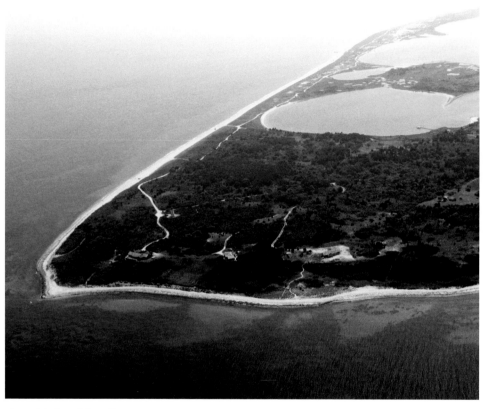

An aerial view of Cape Pogue.

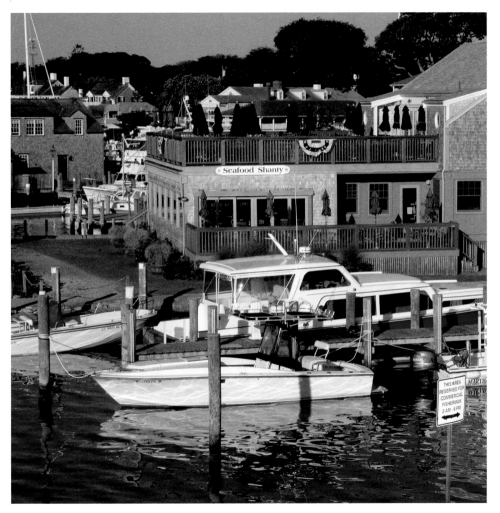

Boats docked in Edgartown Harbor.

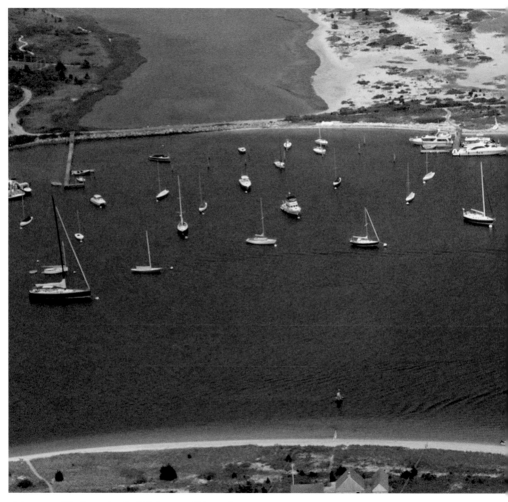

Edgartown Harbor, with the lighthouse visible on the shore.

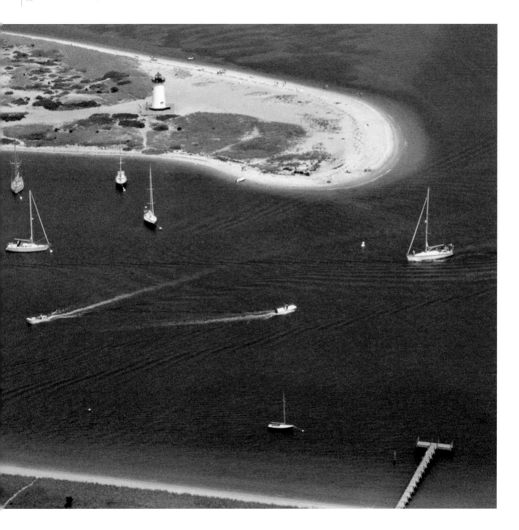

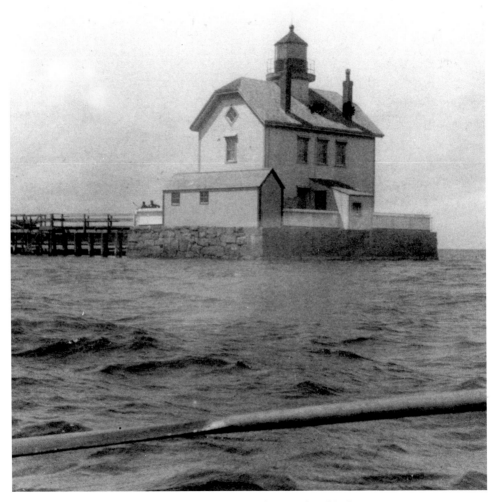

The original Edgartown Lighthouse in 1915. (Courtesy of National Archives)

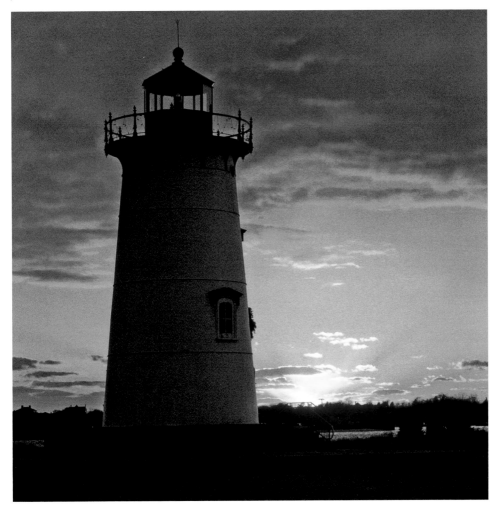

The Edgartown Lighthouse at sunset.

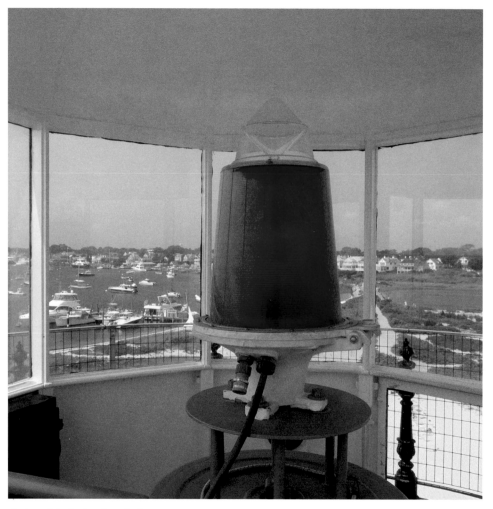

A view of the harbor from the lantern room.

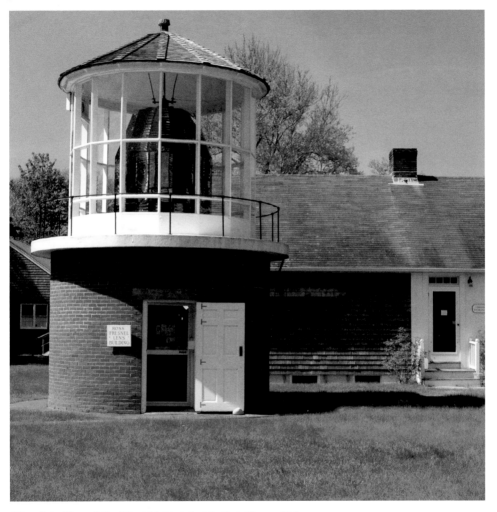

ROSS
FRESNEL
LENS
BUILDING

The original lens of Gay Head Light at the Martha's Vineyard Museum.

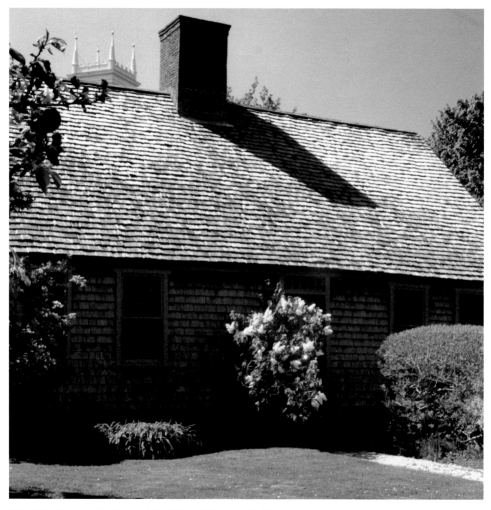

The oldest house on the Vineyard, the Vincent House, is in Edgartown.

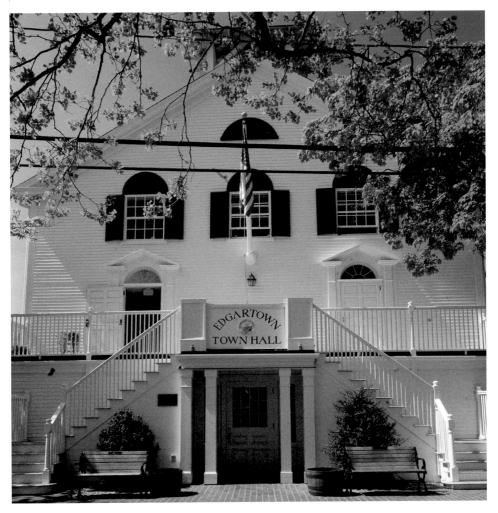

The Edgartown Town Hall.

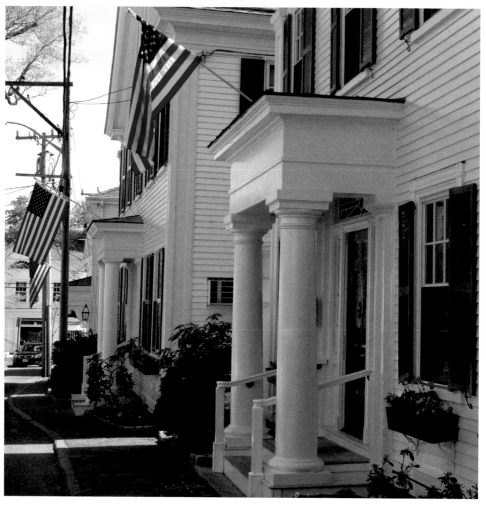

Inns line the street in Edgartown.

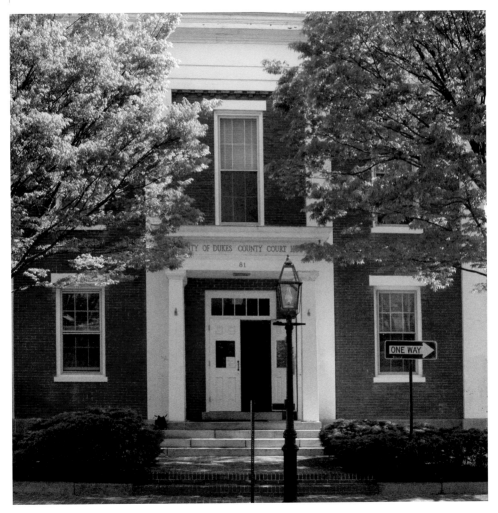

The Dukes County Courthouse.

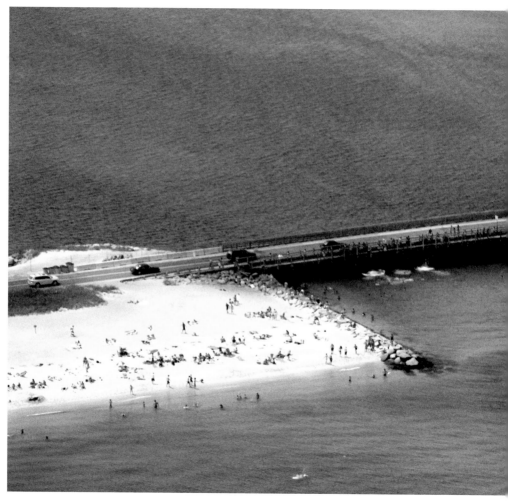

The bridge made famous in the movie Jaws.

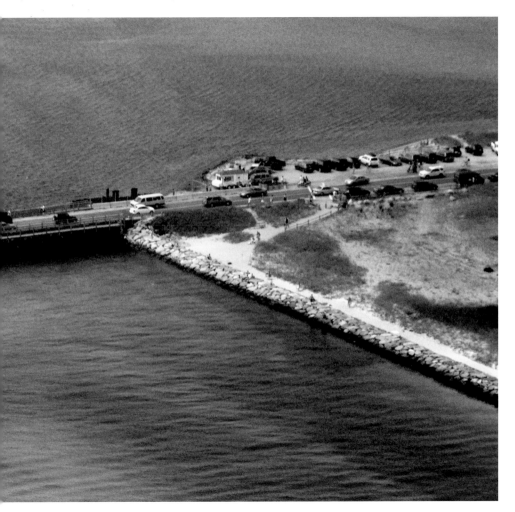

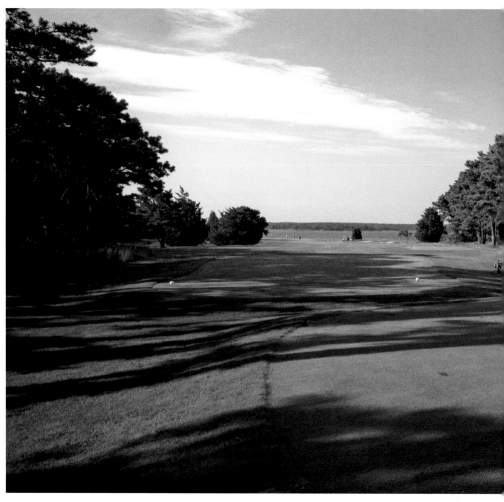

A fairway on the Farm Neck Golf Course.

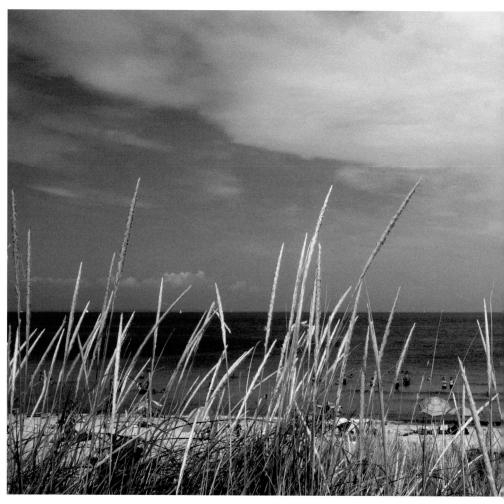

A beach on Vineyard Sound.

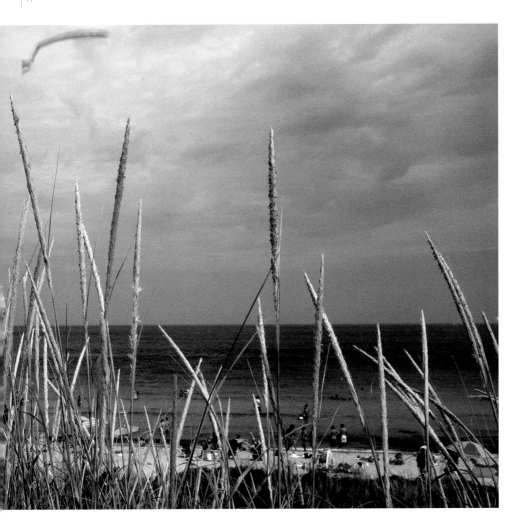

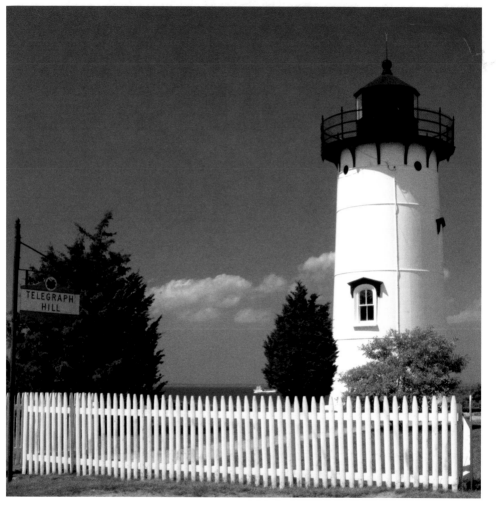

East Chop Lighthouse.

A decoration at a gift shop.

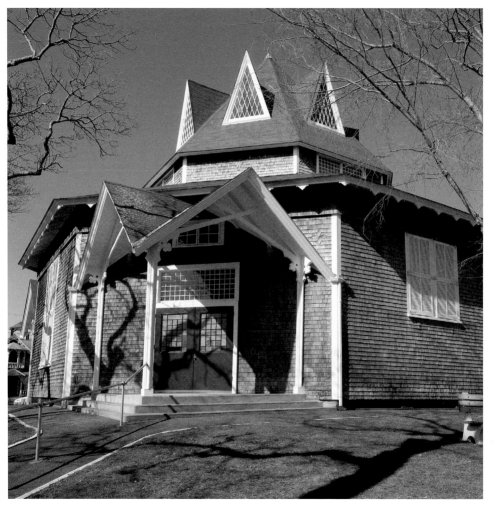

In Oak Bluffs, Union Chapel is the site of many activities and celebrations.

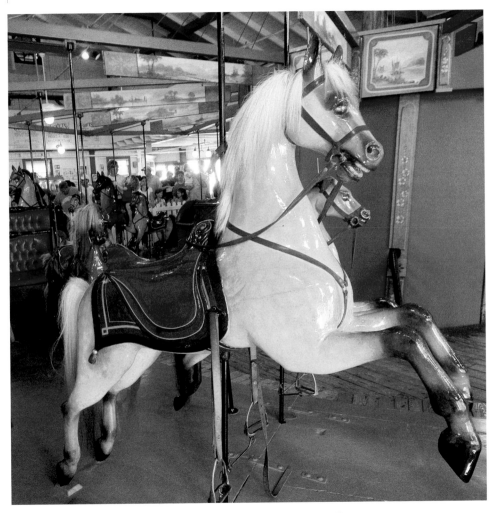

The Flying Horses Carousel is a popular attraction in downtown Oak Bluffs.

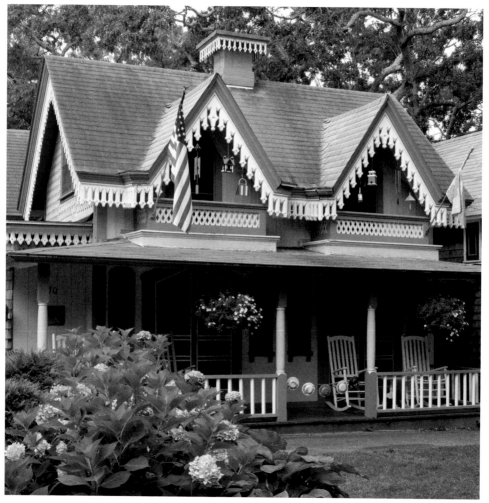

The Lawton Cottage is one of the oldest cottages in the Campground.

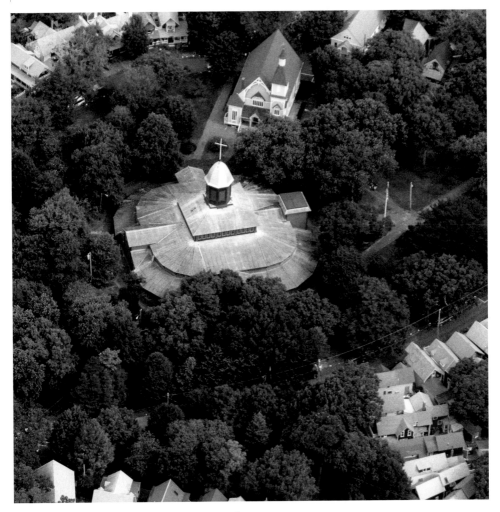

The Tabernacle is in the middle of the Campground.

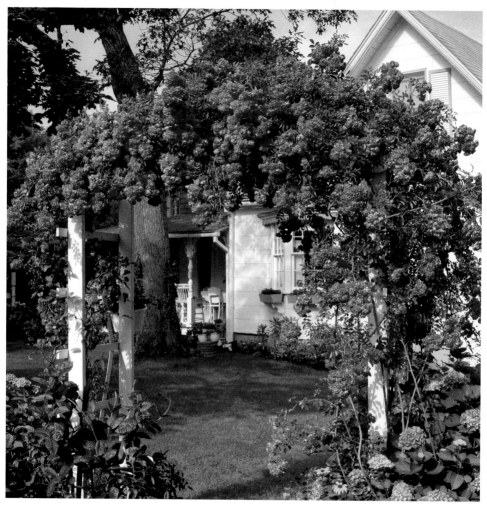

A rose arbor leads to a quaint cottage.

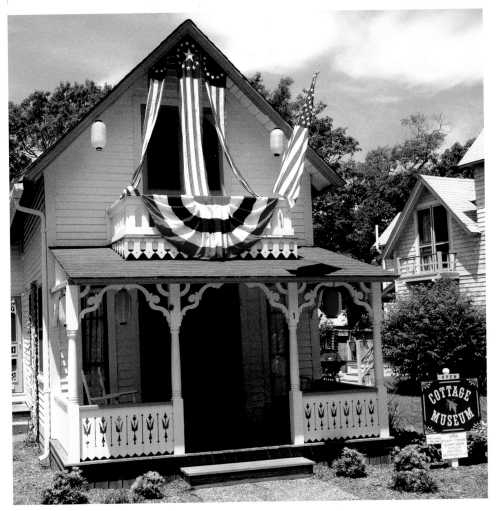

The Cottage Museum is decorated for Independence Day.

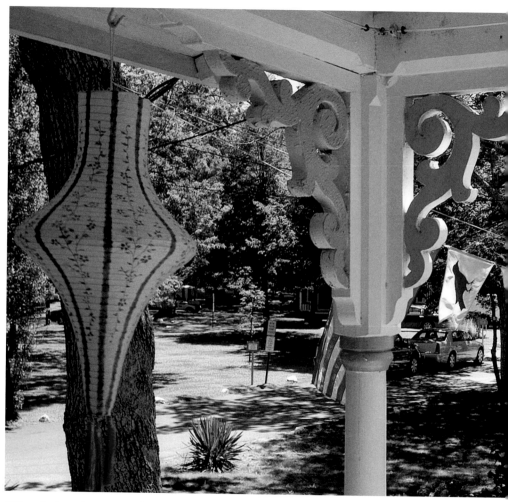

Chinese lanterns decorate a porch.

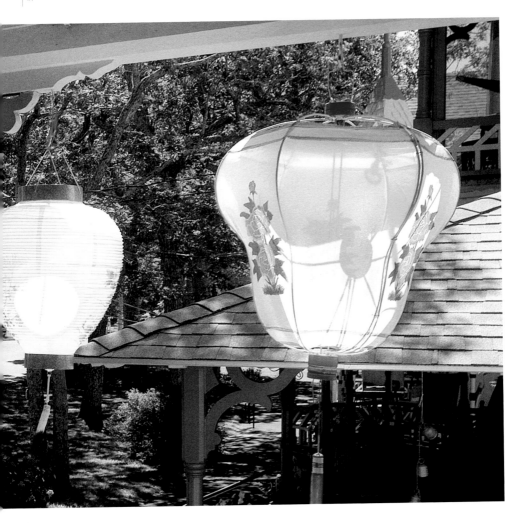

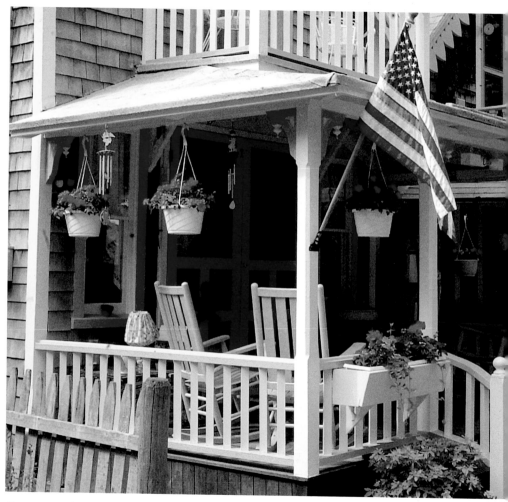

Cottages near the Tabernacle.

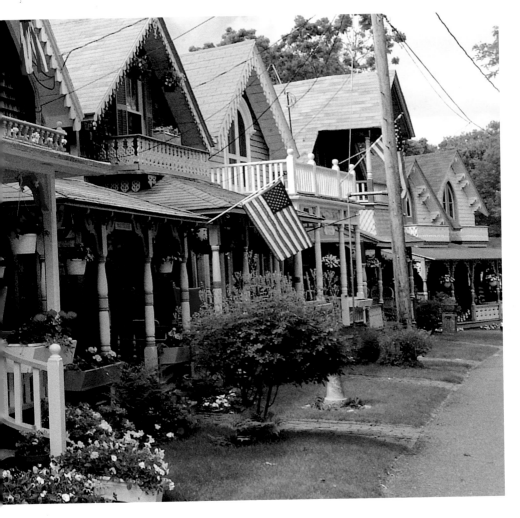

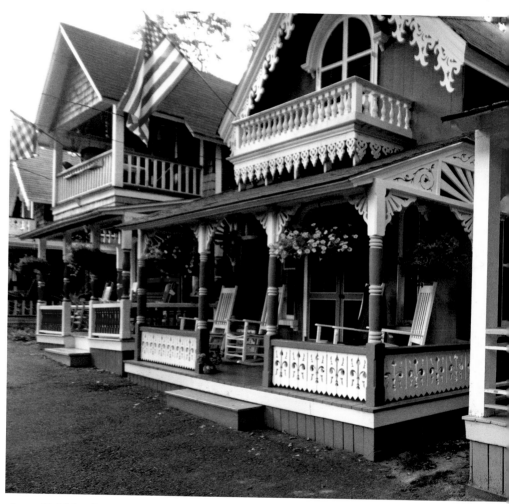

A row of brightly colored cottages.

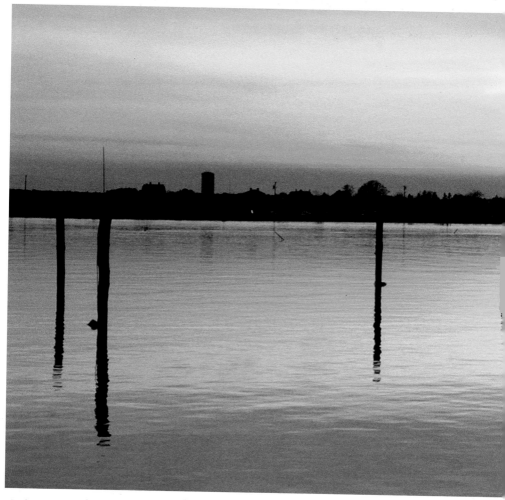

A solitary sailboat in the harbor at sunset.

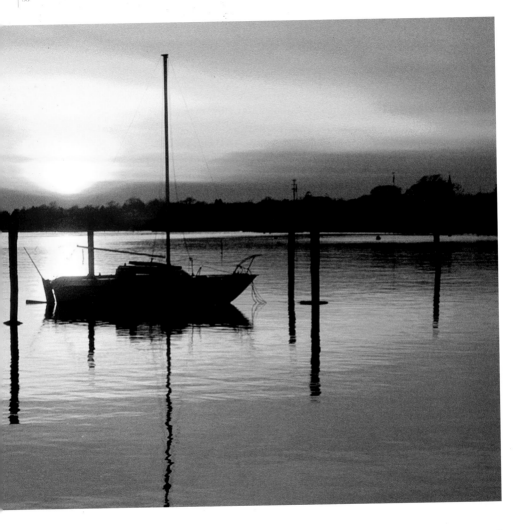

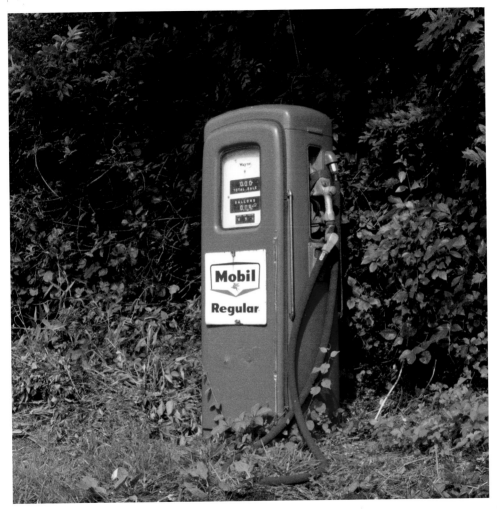

The island's charm is a mix of old and new.

Arthur P. Richmond has been a photographer for more than fifty years. He is the author of more than a dozen books, and his images are also found in calendars and postcards, as well as on display at several galleries in Massachusetts.

Other Schiffer Books by the Author:
Martha's Vineyard Perspectives,
ISBN 978-0-7643-3834-2
Martha's Vineyard Wide, ISBN 978-0-7643-3555-6
Harbors of Cape Cod & The Islands,
ISBN 978-0-7643-3007-0

Library of Congress Control Number: 2016938901

Designed by Molly Shields
Type set in Bell MT

ISBN: 978-0-7643-5161-7
Printed in China

Published by Schiffer Publishing, Ltd.
4880 Lower Valley Road
Atglen, PA 19310
Phone: (610) 593-1777; Fax: (610) 593-2002
E-mail: Info@schifferbooks.com
Web: www.schifferbooks.com

For our complete selection of fine books on this and related subjects, please visit our website at www.schifferbooks.com. You may also write for a free catalog.

Schiffer Publishing's titles are available at special discounts for bulk purchases for sales promotions or premiums. Special editions, including personalized covers, corporate imprints, and excerpts, can be created in large quantities for special needs. For more information, contact the publisher.

We are always looking for people to write books on new and related subjects. If you have an idea for a book, please contact us at proposals@schifferbooks.com.